Pump it up Magazine

TABLE OF CONTENTS

EDITORIAL 6
Page 5

CALYN & DYLI
Hip & Chic California Teen Pop Siblings

GIRL POWER! 11
How female music artists are empowering young women today

WHAT'S HOT!
- Mark Maryanovich - Award Winning Photographer
- Mandie Brice - Celebrity Make-Up Artist
- The Art of Giving by Rock & Roll Hall of Famer Matt Sorum (drummer)

LOOKS! 19
- How can fashion empower women?

MUSIC GEMS
- Roseann Sureda
- Aneessa
- Rusty Gear
- Mikey Hamptons & The Meows
- Drivetime

TOP TIPS 27
Promote Your Music With TikTok

CINEMA
Nettflix Feminist Best Shows

HUMANITARIAN AWARENESS
Teens using girl power to change the world

Pump it up
MAGAZINE

PUMP IT UP MAGAZINE
LINKS

WEBSITE
www.pumpitupmagazine.com

FACEBOOK
www.facebook.com/pumpitupmagazine

TWITTER
www.twitter.com/pumpitupmag

SOUNDCLOUD
www.soundcloud.com/pumpitupmagazine

INSTAGRAM
pumpitupmagazine

PINTEREST
www.pinterest.com/pumpitupmagazine

PUMP IT UP MAGAZINE
30721 Russell Ranch Road
Suite 140
Westlake Village,
California 91362
United States
www.pumpitupmagazine.com
info@pumpitupmagazine.com
Tel : (001) (877)841 – 7414 (toll free number)

EDITORIAL

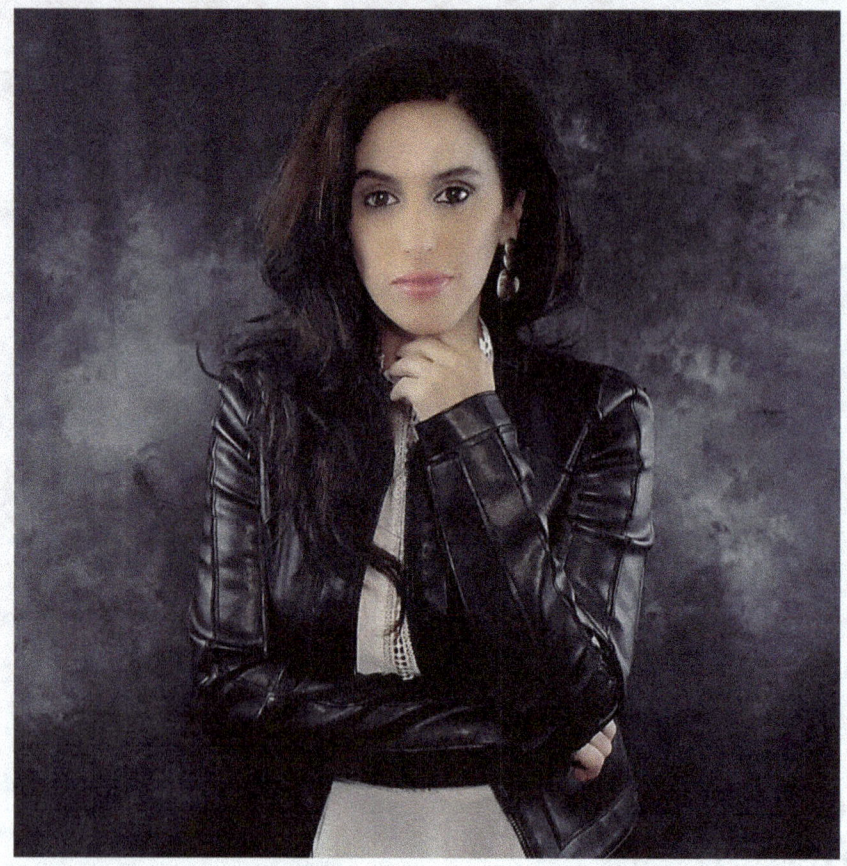

Greeting Pump it Up Magazine Readers,

Welcome to our special Women's Month edition!

Oh don't worry fellas, we have men in this issue also :-)

On the cover, we have the chic and cool talented siblings Dyli and Calyn. This teen pop siblings are making all the right moves in the studio and on the radio.

We also have celebrity photographer Mark Maryanovich who's photography has won numerous awards.

Mandie Brice, celebrity make-up artist has worked with the likes of Kareem Abdul Jabar and many others.

But don't let me give all the goodies away! Pick up your copy today and or check us out online at

WWW.PUMPITUPMAGAZINE.COM

And of course please don't forget to Tune in to Pump It Up Magazine Radio for the latest hits by the world's indie and major artists!

Happy Women's month to all.

Be safe, stay well and pray for peace and equality for all.

Best wishes,

Anissa Boudjaoui

CONTRIBUTORS

EDITOR IN CHIEF
Anissa Boudjaoui

MUSIC EDITOR
Michael B. Sutton
Carter Kaya

FASHION EDITOR
Carol Mongo

STYLE CORRECTOR
Grace Rose

PARTNERS

Editions L.A.
www.editions-la.com

The Sound Of L.A.
www.thesoundofla.com

Info Music
www.infomusic.fr

Delit Face
www.DelitFace.com

L.A. Unlimited
www.launlimitedinc.com

Dyli and Calyn Photography
by
Nick Larson

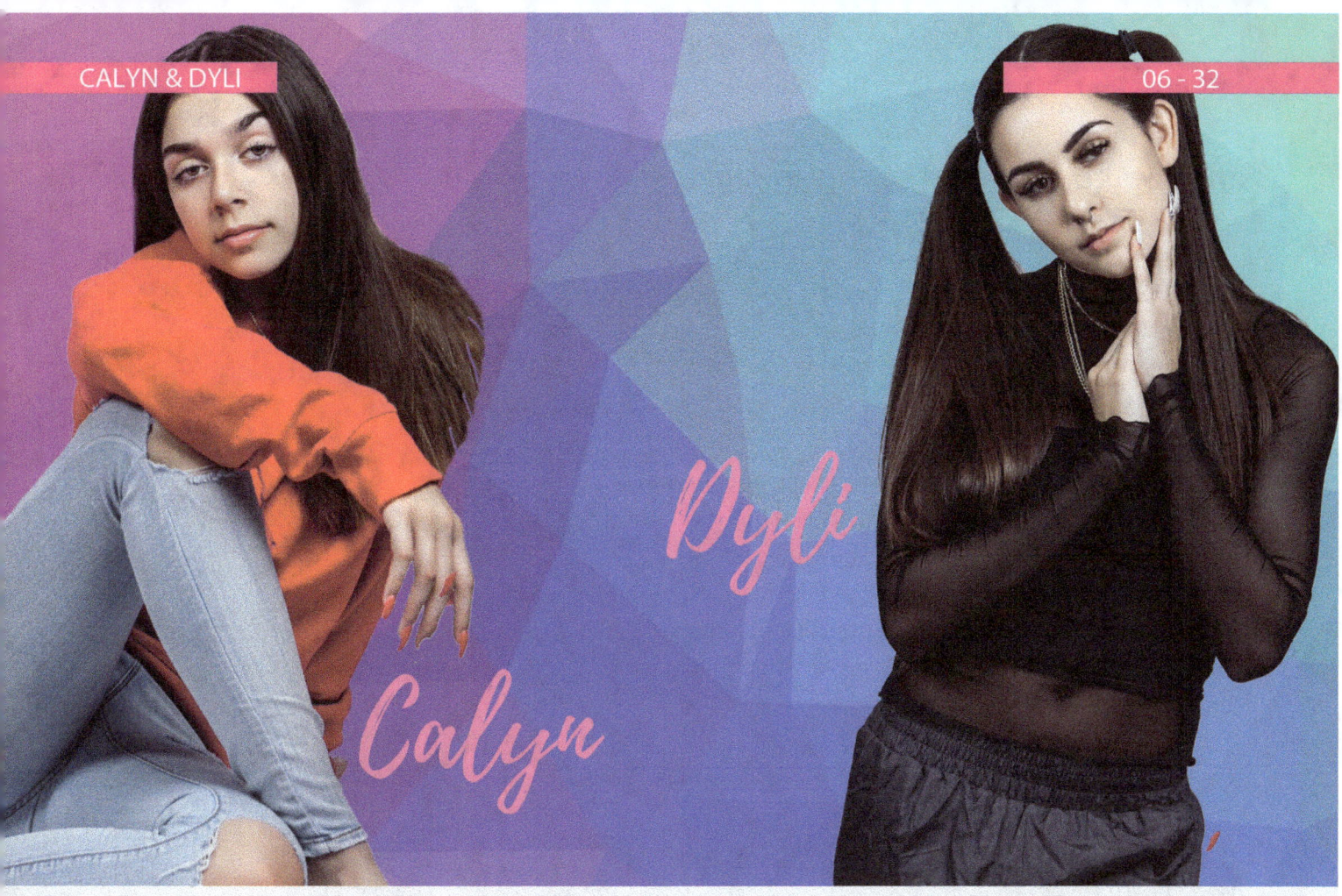

NOCAL sisters **Dyli and Calyn** release yet another brilliant display of talent under Dyli's vanity label, **DaliO Music Inc.**, bringing fresh sounds to attract new fans from all walks of life. The sisters got an early start in the music industry, both releasing their first singles at the age of thirteen and taking streaming sites by storm. Earlier this year, **Dyli and Calyn** released the singles titled **"18+"** and **"Storm"** respectively.

Dyli, has extensive experience in working with professionals including Canadian rapper Madchild, drummer Fabian Egger (Adam Levine, Big Sean) and choreographer Cedric Botelho (Christiana Milian, Jojo, Florida) to bring the best out of her recordings and performances as the audience at the SXSW Music4Miles Spirit Airlines event (Austin, TX) can attest to. However, regardless of professional collaboration, Dyli remains in control of her creative direction, writing her own material, which she publishes under her own label **DaliO Music, Inc.**. In Dyli's most recent work, **"18+"**, modern devices, instruments and 21st century narratives are used to convey coming of age on the dawn of the new decade.

Calyn, the fledgling content creator, sings, writes, plays multiple instruments and makes films for YouTube. Calyn has a passionate effort to make it in the insane world of show business. With this amount of ambition, she is surely set for a soaring career, as it can be heard on her single, **"Storm",** a most personal, melodious piece exploring the boundaries of the highly chaotic world of a young girl trying to make it in the toughest industry there is.

It is evident that with such a head start, the girls have a bright future ahead, with a career path to suppress anyone who came before them in popular music and if pure talent, ambition and perseverance is the key, then the money should be on them.

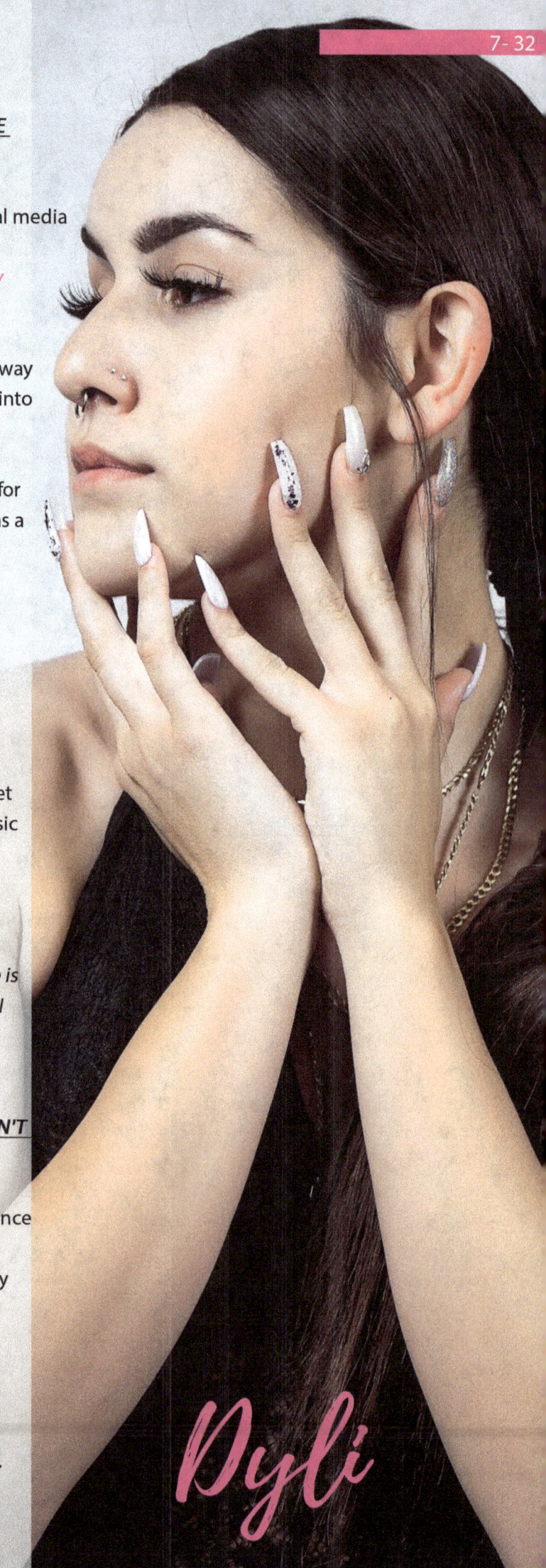

WHAT WOULD YOU CHANGE FOR THE ADVANTAGE OF WOMEN ALL OVER THE WORLD?

CALYN: Support of each other. Especially in the social media world, where I spend most of my time.
It's critical that we build each other up rather than try and break each other down.

DYLI: If I could change anything, I would change the way women are viewed. While we're a quarter of the way into 2020, young girls are continuously shown the uphill battles that women over time have had to face.
I believe this has caused a major lapse in confidence for females today and has created the expectation that as a female, you're "less than".
Confidence is key and could change a lot of things for future generations of women.

**IF YOU COULD MEET AN IMPACTFUL PERSON, WHO WOULD YOU
MEET AND WHAT WOULD YOU TALK ABOUT?**

CALYN: I would definitely love an opportunity to meet Alicia Keys. She has been an inspiration for me in music since I was young. I would love to talk about everything from her strengths to her writing styles & melodies.

DYLI: Personally I would love to meet Billie Eilish. She is such an icon to me. Being yourself is something that I stand for and I believe she radiates that energy.

DO YOU EVER FEEL LIKE BECAUSE YOU'RE YOUNG AND PRETTY, SOME PEOPLE IN THE INDUSTRY DON'T TAKE YOU AS SERIOUSLY AS YOU'D LIKE THEM TO?

CALYN: I used to. In the past I didn't have the confidence to speak up for myself & I was constantly doing what was suggested without expressing my ideas. I actually have a lot of support around me and I've learned to make myself heard.

DYLI: So far, no. I surround myself with people who respect my work and me as a person. I believe it is an existing issue, it's just not something I've run into yet.

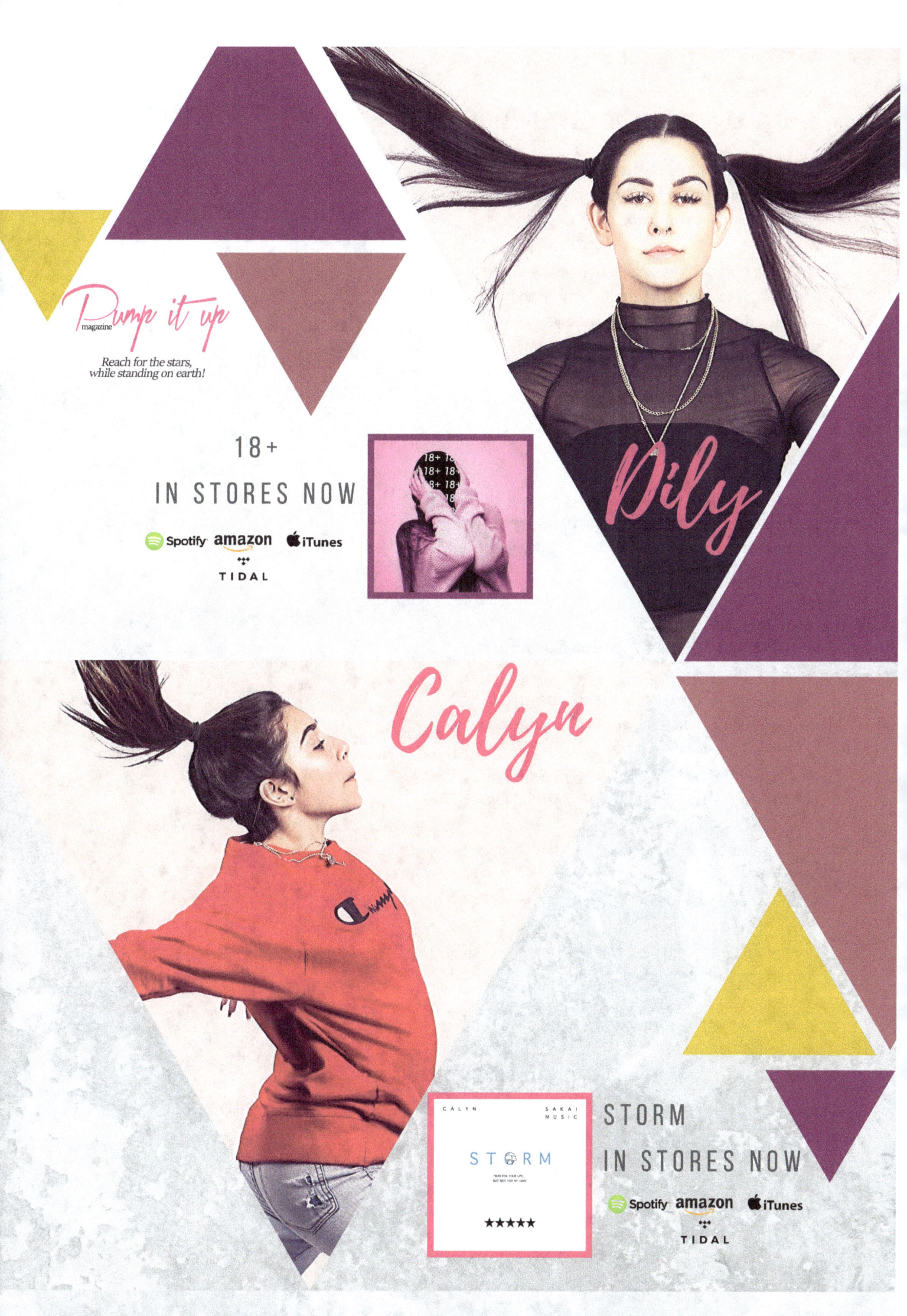

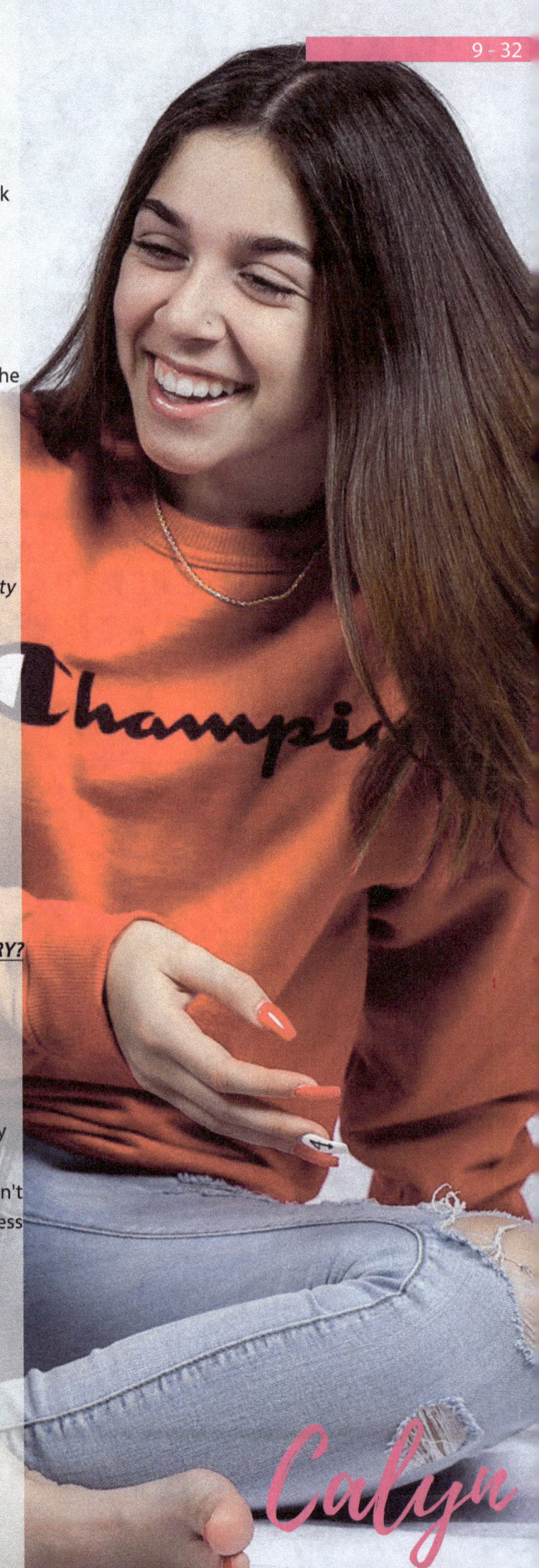

WHAT CAN YOU SUGGEST TO EVERY WOMAN?

CALYN: What I would say to anyone is to try and block out negativity. Really just focus on yourself and constantly moving forward.

DYLI: My number one suggestion to any women, or anyBODY, is to always walk with your head held high. I mean this literally and mentally. No matter the situation,
if you keep your head up, your stance strong and never fold, you'll own the world.

A STRENGTH YOU ARE PROUD OF?

CALYN: A strength I am proud of is probably my ability to speak for myself in certain situations. When I feel strongly about something I won't let my voice be spoken over.

DYLI: One thing I'm proud of with myself, which is something that took me a long time to overcome, is being able to speak my mind.
I try to always make sure things are up to par in my eyes, or that I understand what's going on and why.

IN YOUR OPINION, WHICH QUALITIES ARE MOST IMPORTANT AS A WOMAN IN THE MUSIC INDUSTRY?

CALYN: First of all, confidence-you'll get run over without it. Also, the ability to be open minded and definitely be ready to put in the work..

DYLI: Confidence and hard work are soooo extremely important. Being confident in what you say, do and create can carry you miles, even if the results aren't direct, they will not fail you in the long run. Success comes with effort
and security.

EDITIONS L.A.

GRAPHIC AND WEB **DESIGN**

WEBSITE
CD COVER
LOGO
FLYER
BANNERS
EPK
LYRICS VIDEO
TRANSLATION

We give you the tools to make your song or band to be heard around the world !

INFO@ EDITIONS-L.A.COM

WWW.EDITIONS-LA.COM

SPECIAL **OFFERS** 50% ON LYRICS VIDEOS
HIGH-QUALITY MUSIC LYRICS VIDEO
UP TO 1080P HD VIDEO QUALITY
MODERN AND SIMPLE STYLE
$250 FOR MUSIC VIDEO UP TO 4 MIN
$350 FOR MUSIC VIDEO UP TO 5 MIN

FOR MORE INFO VISIT WWW.EDITIONS-LA.COM

HOW FEMALE MUSIC ARTISTS ARE EMPOWERING YOUNG WOMEN TODAY

DUA LIPA

Her main goal when creating music is to empower her listeners. This stems from her modeling career, when a manager told her to lose weight even though she was at a healthy weight already. Also, *SHE WALKS ON WATER IN HER NEW RULES VIDEO.*

HALSEY

Halsey writes her music based on her experiences with bipolar disorder, being half-black and half-white, suffering from endometriosis, being bisexual and a feminist. She gives zero hoots about what her haters think and her songs are AMAZING.

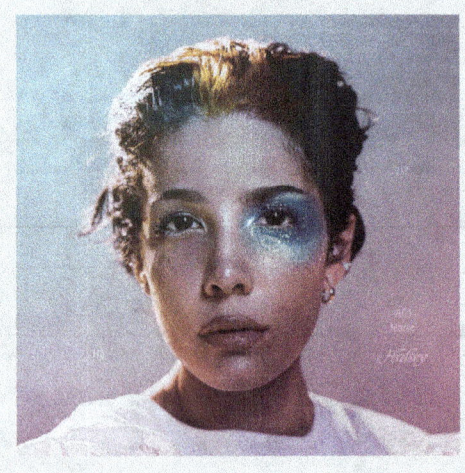

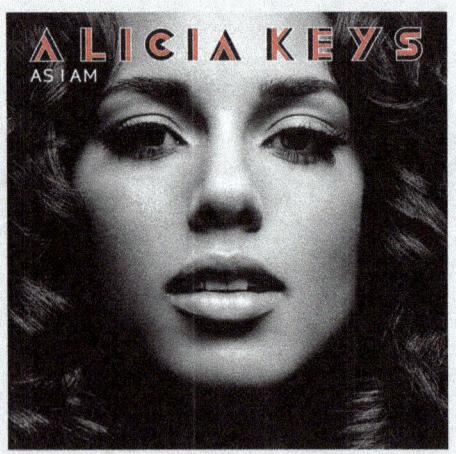

ALICIA KEYS

She's a classic. No-makeup empowerment. Black girl empowerment. Need I say more?

BEYONCÉ

Would it be an empowering females list without Queen B? Her music strives to empower women and bring them up, saying that we are strong creatures that shouldn't be challenged.

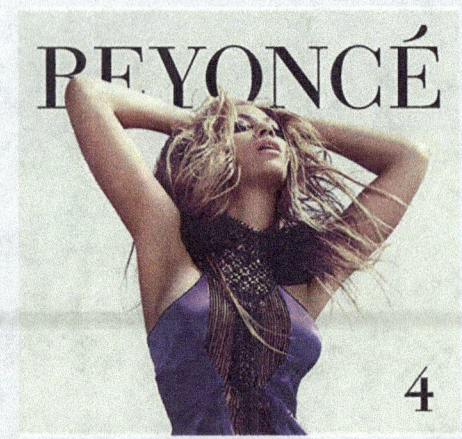

HOW FEMALE MUSIC ARTISTS ARE EMPOWERING YOUNG WOMEN TODAY

ZARA LARSSON

She made an impression on my mind with this iconic photo. She has no shame in what she does, and if you look at her Instagram, you can see that she's a big feminist.

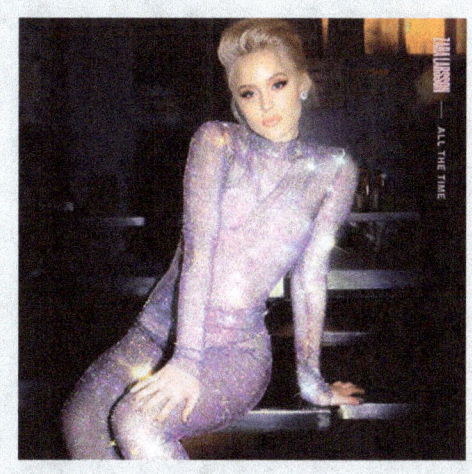

LADY GAGA

Lady Gaga is honestly a queen. Like many artists on this list, she has no shame. One song I want to point out is "Til It Happens to You", which she wrote for The Hunting Ground, a documentary about college rape. She is an advocate for equality and helps fight for rape victims as well.

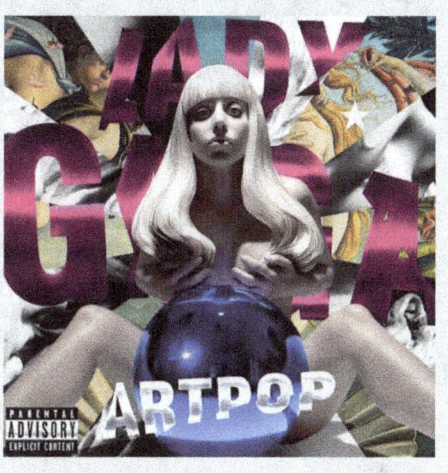

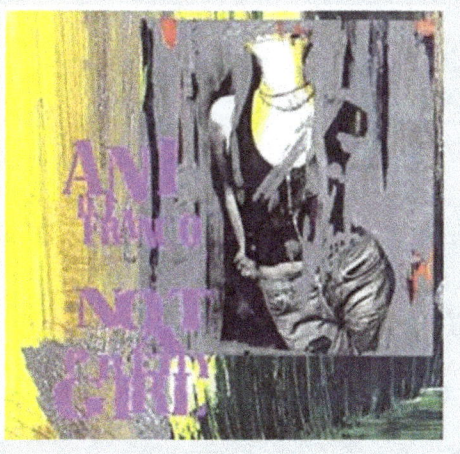

ANI DIFRANCO

Would it be a true list of empowering female artists without Ann DiFranco as well? She is an outspoken feminist icon and she expresses this through her songwriting.

LITTLE MIX

This girl group helped revive girl groups after their formation in the X Factor UK. Their music shows that women don't need men to be strong and that you will always have support in what you do.

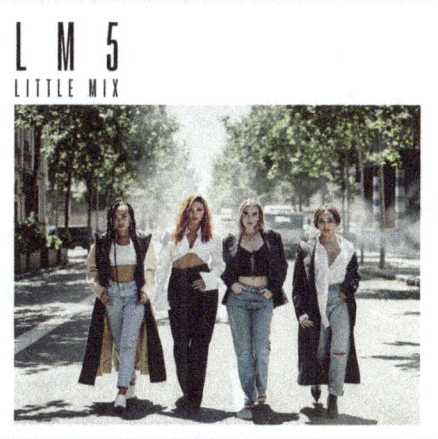

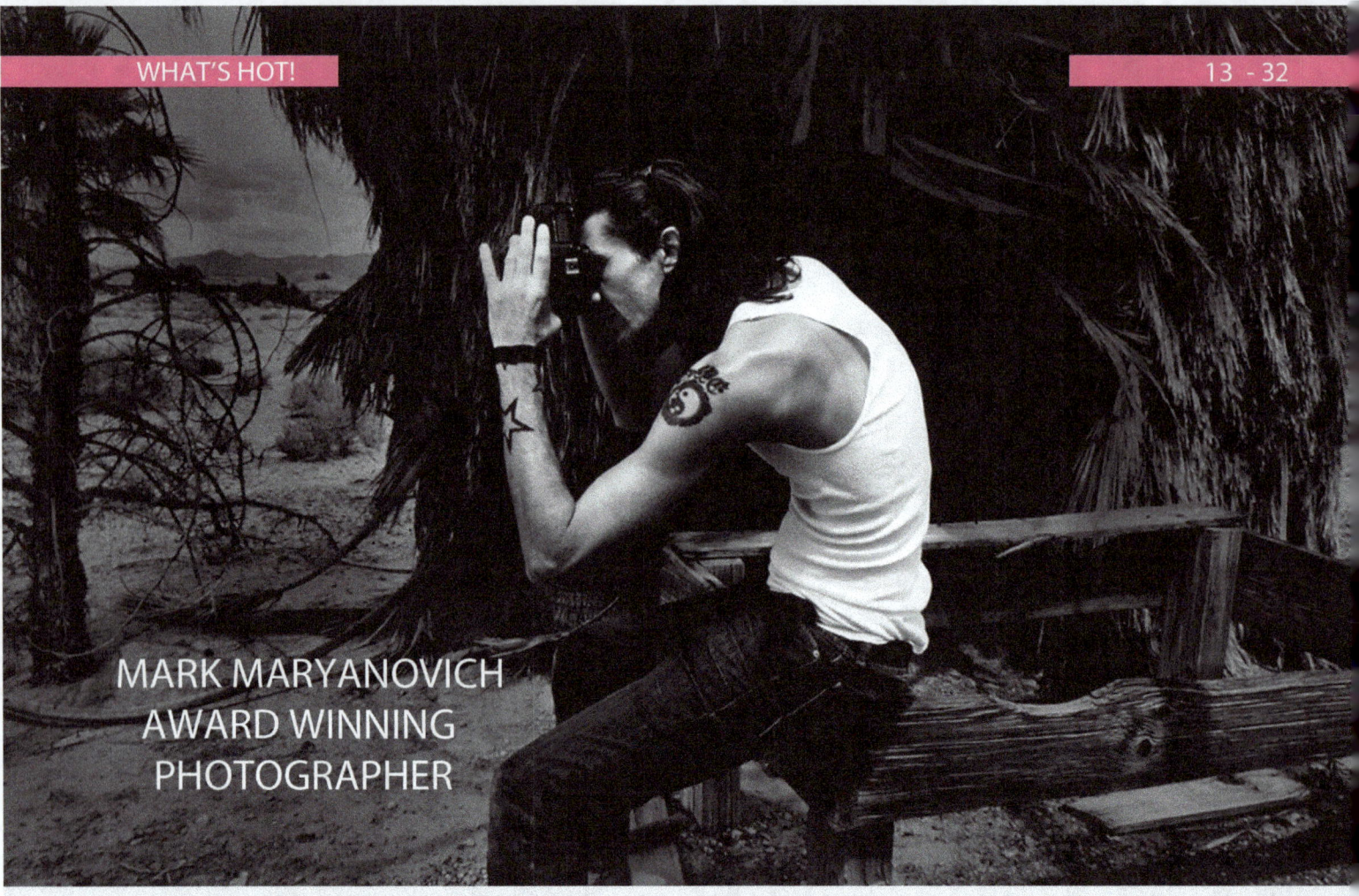

MARK MARYANOVICH
AWARD WINNING
PHOTOGRAPHER

Award-winning photographer Mark Maryanovich has captured an impressive variety of artists including Chris Cornell, Bob Rock, Chad Kroeger, Elliott Smith and Henry Rollins.

Mark Maryanovich's photographs appear as album covers and artwork for companies such as Sony, EMI, Warner Chappell Music, and Mark has been nominated four times (twice in the same category in 2012), and has received two Canadian Country Music Awards for Recording Package of the Year.

Mark's commercial clients include Gibson Guitars and Peavey Electronics, and his work has been published in Rolling Stone and Billboard magazines. Mark had the honor of providing the author photo for best selling biographer Robert Lacey's Model Woman: Eileen Ford and the Business of Beauty, and book cover images for the legendary Randy Bachman's autobiography Vinyl Tap Stories, and Matt Sorum's autobiography Double Talkin' Jive: True Rock 'N' Roll Stories From the Drummer of Guns N' Roses, the Cult and Velvet Revolver.

Mark has been recognized by the prestigious Photo Review magazine competition with his selection as a prominent entry, and by the California art community, with his placement as a finalist in the Images From A Glass Eye International Juried Photography Show, and honorable mention in the American Icon Art Competition.

Because of his work in this genre, the esteemed Annenberg Space for Photography selected Mark to be part of their slideshow exhibition Country: Portraits of an American Sound, which celebrates the pioneers, poets and icons of country music.

INTERVIEW WITH AWARD WINNING PHOTOGRAPHER MARK MARYANOVICH

HOW DID YOU FIRST GET INTO PHOTOGRAPHY, AND HOW DID YOUR CAREER DEVELOP?

I first began my photography career while living in Montreal Canada. I had the opportunity to meet a phenomenal photographer who was working with a rock band my brother was managing at the time. We instantly became friends, and over the next couple years he mentored me in photography and changed my life. I then moved to Vancouver Canada and began my career as a music portrait photographer. After nearly a decade of developing my craft and style, I headed south to Los Angeles, California. I began working in LA and other cities throughout the States, including New York, Philadelphia, Pittsburg, Austin, Nashville, Phoenix and Las Vegas.

WHAT GEAR DO YOU SHOOT WITH THESE DAYS?

These days I primarily work with Canon cameras, though throughout my career I've used many different brands and formats.

Bronica, Pentax, Lumix, Nikon, and every kind of film and Polaroid.

WHAT ARE SOME UNIQUE CHALLENGES THAT COME WITH WORKING WITH INDIE MUSIC ARTISTS?

The biggest challenge I find in working with indie music artists, or any music artist, is that they usually would rather be performing, recording or writing music than getting their photo taken, which I can completely understand. I think it's my job to be organized, quick and efficient to help make the process as painless as possible.

HOW DO YOU DETERMINE HOW MUCH TO CHARGE FOR YOUR WORK?

Usually what determines the cost of the work is, the time it takes, the number of set ups (different shots requested), the amount of prep work (location hunting, travel, etc.) and the amount of post production work involved. I found in my experience that no two jobs are ever the same.

WHAT IS THE ONE PHOTO YOU'RE MOST PROUD OF CREATING?

I'm very grateful for every opportunity I've had throughout my career to work with some fantastic artists and individuals.
The photo I'm most proud of creating is the portrait of Billy F Gibbons from ZZ Top.
The portrait was taken during the first webisode of The ART of GIVING, a new series that exists to create awareness for the charitable causes championed by the world's most iconic artists, created by Matt Sorum (legendary drummer of Guns N' Roses, The Cult, and Velvet Revolver) and myself. The autographed print of the portrait is at auction via Charitybuzz.com with proceeds benefiting Adopt the Arts Foundation, a non-profit organization keeping the arts alive in America's public schools.

WHAT'S THE BIGGEST LESSON YOU'VE LEARNED SO FAR IN PHOTOGRAPHY?

One of the biggest lessons I've learned is to be over prepared. Things will never go exactly as planned, bad weather, locations fall through, people are late, anything can happen on a shoot. Being able to pivot and adjust quickly to any situation comes from being prepared for anything.

To know more about Mark Maryanovich, please visit: https://www.markmaryanovich.com

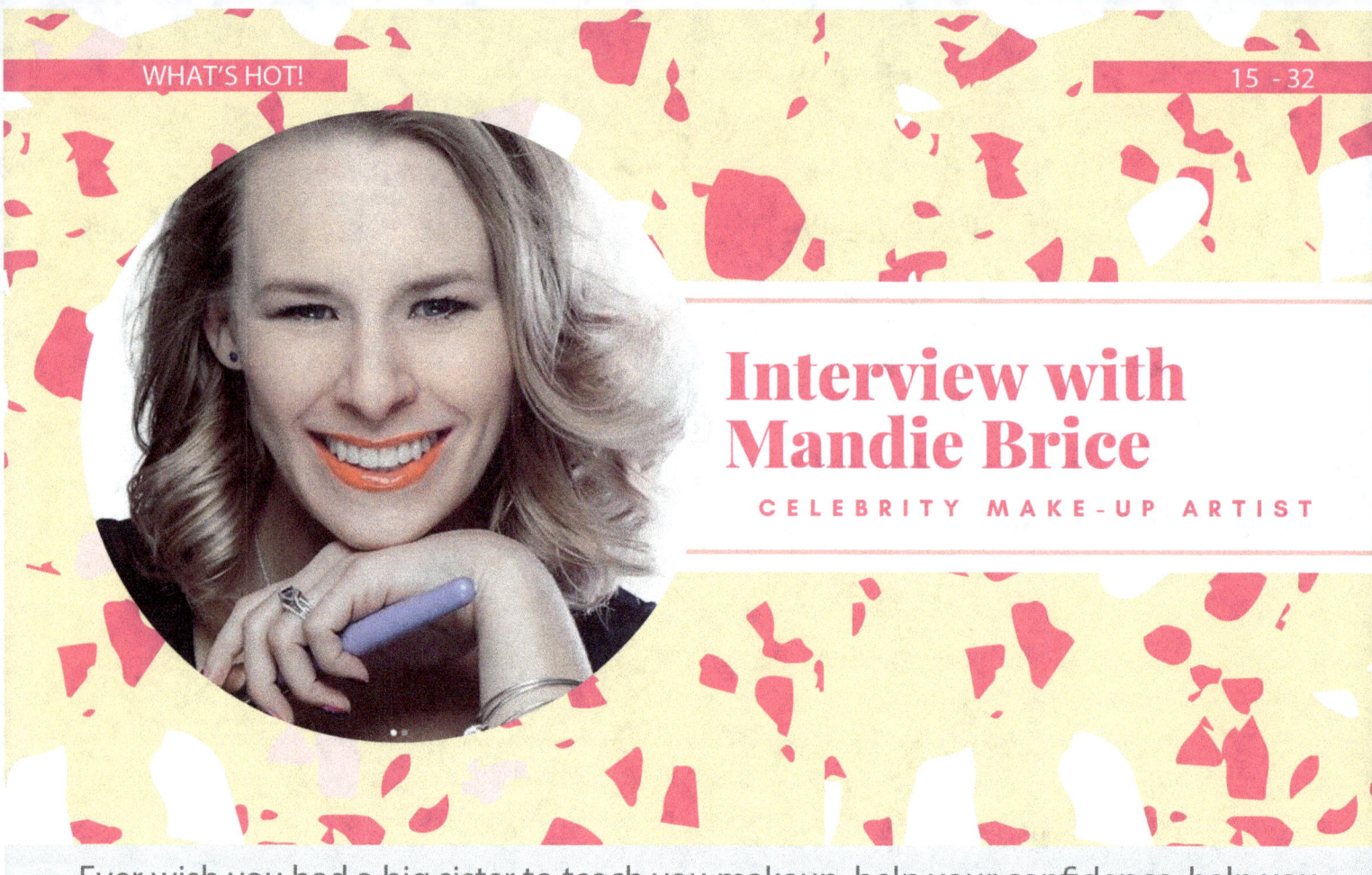

Interview with Mandie Brice
CELEBRITY MAKE-UP ARTIST

Ever wish you had a big sister to teach you makeup, help your confidence, help you find life balance, give you the motivation to go after your dreams, give you health and wellness tips, and basically be the "in your corner" cheerleader to help you live your best life? Look no further!

As a kid, Mandie Brice was obsessed with fashion, modeling, and makeup – all things "looking good." Mandie Brice have stuck to both parts of my roots – now as an educator, model, and makeup artist!

As a makeup artist, Mandie Brice have worked with big celebrities (like 7'2" tall Kareem Abdul-Jabbar, for example), big brands, and with big magazines and tv stations.

While Mandie Brice adores playing dress up, Mandie Brice is still super passionate about learning and helping others learn.

Mandie Brice made an online makeup course to empower women to learn to do their own makeup confidently, and share as much knowledge as she can by writing! You may have seen that published on Forbes.com, Huffington Post, Apple News, Makeup Artist Magazine, and/or Women's Health.

Having taken the risk of quitting my day job as a teacher and living to tell about it has inspired my to share stories of other big risk takers… So I created the Bold Moves Podcast, with the hopes that listeners will hear some of their own qualities in the amazing stories and be inspired to make bold moves of their own!

I believe that if you look and feel better, you'll do everything else better, and I've made it my mission to share everything I've learned.

INTERVIEW WITH CELEBRITY MAKE-UP ARTIST MANDIE BRICE

HOW LONG HAVE YOU BEEN A MAKEUP ARTIST AND HOW DID YOU GET YOUR START IN THE INDUSTRY?

It all depends on how you define it! I've been fascinated with makeup since I was a little kid, and played with it for as long as I remember. I have a training certificate from 1998, when I was working at the cosmetics counter of a Walgreens during high school, but I would say my real career as a pro started about ten years ago. I had been modeling for a while on the side of being a teacher, so in summers and on weekends. I had been doing my own makeup for a lot of shoots, and sometimes did it on other models, and even modeled for makeup classes, where I did my best to soak up as much knowledge as I could! Then I eventually became even more successful as a makeup artist than model, even though I still do both!

CAN YOU TELL US ABOUT YOUR BOOK "BEST FACE FORWARD"?

This is a collection of makeup skills and practical looks (from a 5-minute look, to a daytime look, to an evening/date night look or makeup for photography) as taught by a professional makeup artist with celebrity experience and a teaching degree.

It is based upon a digital makeup course that shows self-application as well as on a variety of models with different ages, skin tones, and eye shapes, and the book uses the same inclusive approach.

There's also an extensive glossary of terms, product recommendations, and other resources, including how to select complexion makeup/foundation, different brushes and their uses, brush care, and your makeup shopping list. It is available on my website and Apple Book Store

WHAT DO YOU LOVE MOST ABOUT MAKE UP?

I love the confidence that people get from looking their best. It can be so transformative for people to feel amazing because they look amazing.

DOES EVERYONE LOOK BETTER WITH MAKE-UP?

I would say yes, but it doesn't always take much!
There are lots of people I'd like to give a make-under, and put less on. I'm very fond of a more natural look as opposed to dramatic glam!

WHAT THREE MAKEUP ITEM SHOULD NO WOMAN LEAVE HOME WITHOUT?

I don't think there's any specific things that are must-haves for every single person. It varies because some people have different needs or different features that are better to accentuate, so it depends on what you're working with!
What is the most important beauty advice that you can give to women?
I think the biggest key is to stay true to themselves.

WHAT ADVICE CAN YOU GIVE TO PROSPECTIVE STUDENTS THINKING ABOUT AN EDUCATION AND CAREER IN MAKE UP ARTISTS?

I strongly recommend getting licensed and being strict about rules regarding safety and hygiene, but more creative in the artistry aspects.

To know more about Mandie Brice, please visit: www.MandieBrice.com

DELIT FACE

Social Media For The Entertainment World
MUSIC & MOVIE Industry

SINGER
SONGWRITER
MUSICIANS
PRODUCERS
PUBLISHERS
DISTRIBUTORS
MUSIC SUPERVISORS

ACTORS
DIRECTORS
PRODUCERS
DISTRIBUTORS
SET DESIGNERS
SCRIPT WRITERS
EXTRAS

MAKE UP ARTISTS
HAIR STYLISTS
PHOTOGRAPHERS
GRAPHIC DESIGNER

Register now FREE and connect with people in your industry
www.delitface.com

WHAT'S HOT!

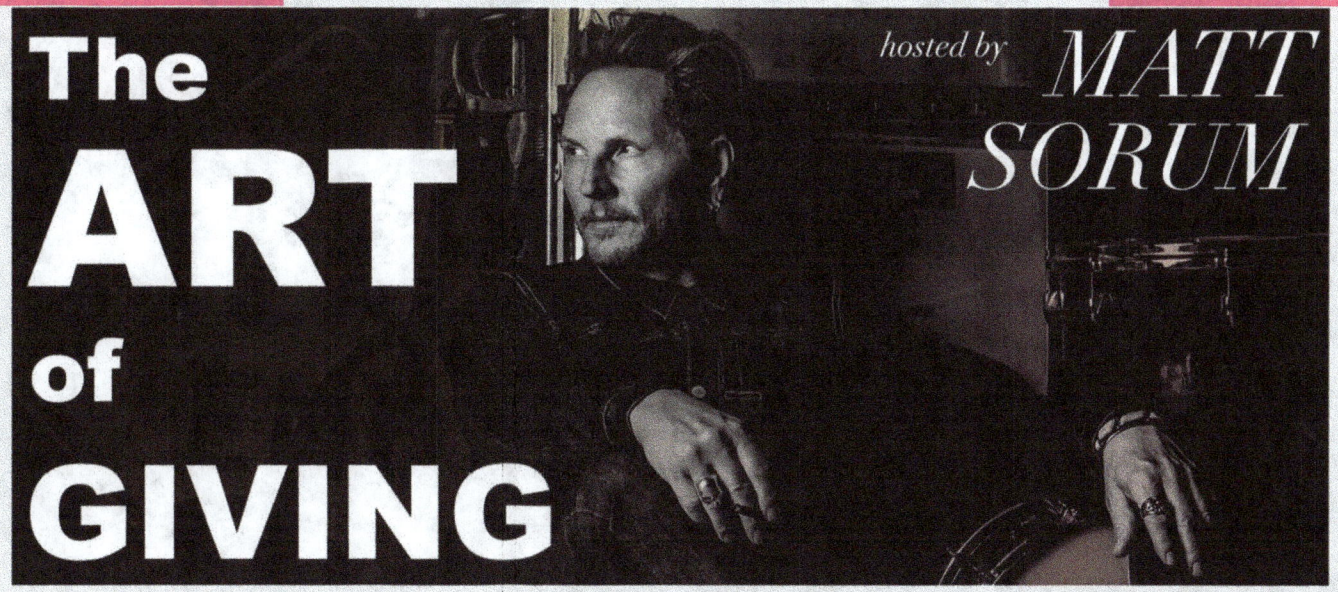

The ART of GIVING, a project showcasing the charitable causes championed by the world's most renowned Artists in the realms of music, entertainment and fine art, launched on February 1, 2020. The project was created by Rock & Roll Hall of Famer Matt Sorum (drummer of Guns N' Roses, The Cult & Velvet Revolver), and award-winning music portrait photographer Mark Maryanovich. The ART of GIVING is a charitable proceeds project featuring photo shoots with some of the world's most iconic artists, with brief video interviews based on the causes they support.

Each installment brings about capturing a one-of-a-kind portrait signed by the artist. The autographed limited edition print is being auctioned via Charitybuzz.com with all net proceeds donated directly to a charity chosen by the artist. The video interviews are being broadcast online at www.theartofgiving.art with a link to the Charitybuzz auction page. "With the world, the way things are going, you know, people gotta get out there and pitch in, and help just make the world a better place…We've been so blessed, playing music all of our lives, and meeting so many people all over the world, that it's sort of a natural fit for us to just say, hey man, how can we help?" said co-creator Matt Sorum.

The ART of GIVING provides a unique platform to showcase the worthy causes championed by the world's most celebrated artists, providing fans access to their favorite icons, with an easy method to join them in supporting their chosen charities. The first webisode features their first guest star Billy F. Gibbons of ZZ Top. The interview is live at www.theartofgiving.art and the signed print is available for auction at Charitybuzz.com from February 18 to March 4, 2020. All net proceeds from the autographed print are donated directly to Mr. Gibbons' charity of choice, Adopt The Arts Foundation. Adopt The Arts is a 501(c)(3) non-profit funding arts programs in public elementary schools. Co-founded in 2012 by Matt Sorum, and activist and entrepreneur, Abby Berman, Adopt The Arts is supported by Jane Lynch, Shepard Fairey, among others.

It is the mission of Adopt The Arts Foundation to bring together well-known artists, public figures, entrepreneurs, policy makers and the general public to save the arts in America's public schools. Check out the premiere webisode of The ART of GIVING, with host Matt Sorum!

Connect with The ART of GIVING on **WWW.THEARTOFGIVING.ART** and Instagram, Facebook and Twitter.

DOUBLE TALKIN' JIVE

TRUE ROCK 'N' ROLL STORIES *from the drummer of* GUNS N' ROSES, THE CULT, *and* VELVET REVOLVER

FOREWORD BY
BILLY F GIBBONS

MATT SORUM

WITH LEIF ERIKSSON AND MARTIN SVENSSON

ROSEANN SUREDA
"It's Called Love"
One of the most promising albums to have emerged from the jazz world this year

It's Called Love revisits the confluence of a genre's past and present, incorporating Jazz and R&B rhythms while still retaining the free improvisation and harmonic complexity of the most forward-looking jazz. On her new album, Roseann Sureda takes an approach that feels alluring and mysterious, she also proves herself a sharp vocalist attuned to the importance of group dynamics. She sounds skilled and mature enough as a leader to know that jazz albums work best when the band operates as a single organism. The group interplay here is the key to the album's success, but it's also clear that Roseann Sureda is a maestro at singing.

You can practically visualize the sound emanating from each instrument as she works her way through shifting harmonies, as on the self-titled opening track. Every note counts. But for the most part, Roseann Sureda isn't trying to show off; though her performance is often intimate and suggestive, breaking off at the peak and producing further tension. What happens next with the rest of the album is transformative. Roseann Sureda continues to sing so brilliantly, any listener would let her continue solo for ten minutes or more, instead of the accompanying two or three instruments that do their best to match the singer's vocal power. You can imagine the intensity the players had while engaging Roseann Sureda, with hands looking like some kind of crazy spider, crawling up and down the length of the guitars and piano. When they all come together, they sound invigorated, ready to play a set that's going reduce some of the audience to tears, especially with songs like "Through the Eyes of a Friend" and "Tribute."

Roseann Sureda also embraces the dynamic typical of so many jazz records, in which a soloist emerges and then bows out occasionally throughout the entire song. But she sometimes does it differently, creating ample space for the instrumentation to shine through while she belts out and holds a note, alternating on a series of short, declarative passages that build in intensity as the rhythm section heats up. The rhythm itself is mostly on a slow tempo that makes you feel more in tune not only with the music and yourself but with other people too. Such exchanges give the music a cyclical quality, an ebb and flow that keeps things floating just above the surface.

Some songs like "You're No Good" and "Stand up" and "Be Counted" are loose, with gnashing funk beats over complex rhythms, which play no small part in these high-wire acts; while listening to "Beauty of the Islands" gets you to discover a different area of sound that you could use to create certain calming and soothing scenarios. In spite of this refreshing approach to jazz, you may find yourself yearning for more. It's Called Love shows Roseann Sureda unburdened of her role that sees her at center stage, as her sound is so appealingly crisp and bright that you get the sense she could sing an entire night's performance with solo material without losing your attention. It's Called Love is one of the most promising albums to have emerged from the jazz world this year, but it's clear that Roseann Sureda is just getting started!

To know more about Roseann Sureda, please visit:
roseannsureda.com
https://www.facebook.com/RoseannSuredaMusic/
https://twitter.com/Sureda

SMOOTH JAZZ – URBAN A/C SONG
ABOUT LOVE THAT KNOWS NO BOUNDARIES

Just to be with you

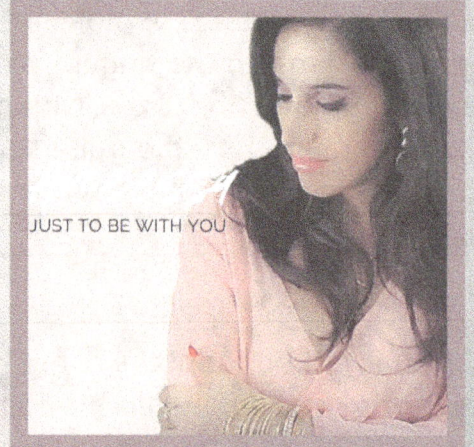

Aneessa

MARCH 20TH – PRE-ORDER MARCH 13TH

WWW.ANEESSA.COM.

MUSIC GEMS

Rusty Gear is an American singer-songwriter who leads a collaboration of great musicians to create and record original country, blues and southern rock music. Rusty's first album, Happy Ending, was released in 2018, followed by Second Gear, released in 2019. Rusty's first single, Wondering Why, **reached number one on Europe's Hotdisc Top 40 country music chart** and **number 51 on Billboard's Country Breakout Chart in the US**. Happy Ending Remix reached **number 21 on the Hotdisc Top 40** and the country version of the classic Christmas carol, In the Bleak Midwinter, receives radio play on Music Row stations during the holidays. Rusty released High Gear in 2020, which has four new original songs and a Remix of Won't Forget.

On High Gear, Tequila Won't Solve Your Problems is receiving radio play in Europe and is charting on the Hotdisc Top 40

and Sorry Excuses, featuring the vocals of Bekka Bramlett, is playing on blues radio in the United States. **Rusty Gear original songs have been streamed over 475,000 times on Spotify**, with Jake Brakes, The Writer and Won't Forget widely playlisted.

To know more about Rusty Gear, please visit: http://www.RustyGearMusic.com

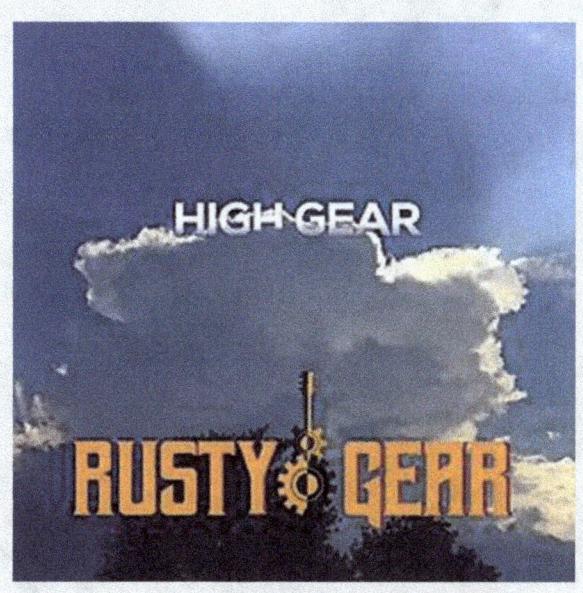

Mikey Hamptons & The Meows are a true Rock experience influenced by none other than the best of the past and present in Rock Music ...

The Meows feature a unique sound that could be described as a cross between Fuel and Ozzy. Some of the songs indeed, though are an obvious giveaway of **influence by The Beatles and The British Invasion.**

Mikey Hamptons, always writing, and always recording new material is constantly looking forward to the next record: "To improve, and grow as a songwriter and recording artist.

"Okay, I'm Ready To Rock Now", the debut CD from Hamptons, is sure to please some of the most die-hard classic rock lovers as well as younger Oasis, Nirvana, Green Day and Foo Fighter fan.

Mikey Hamptons & The Meows are destined to enhance the history of Rock Music!

To know more about Mikey Hamptons & The Meows, please visit:
mikeyhamptonsthemeows.hearnow.com/

YOUR MUSIC CONSULTANT

"YOU BELIEVE, SO DO WE!"

We Can Help You To Grow Your Business

We are a monthly based service, we put faith in artists who has major potential, believed in them, and who are willing to spend their time and own money to work with us in building a successful music career!

Digital Marketing Services

SOCIAL MEDIA - STREAMING SERVICES - MUSIC DISTRIBUTION - PRESS RELEASE - PRESS DISTRIBUTION - PR

Radio Airplay and TV Commercial

TERRESTRIAL AND DIGITAL RADIO CAMPAIGN AL GENRES EXCEPT HEAVY METAL - CABLE TV AND MAJOR NETWORK COMMERCIAL

Licensing & Booking

CONCERTS, LIVE MUSIC, EVENTS, CLUB NIGHTS - RED CARPETS - FOREIGN LICENSING AND SUBOPUBLISHING

Why Choose Us ?

3 DECADES OF MUSIC BUSINESS EXPERIENCE
Platinium and Gold Records
MOTOWN RECORDS
UNIVERSAL
SONY
CAPITOL RECORDS

WE WORKED WITH:
Kanye West - Jay Z - Stevie Wonder - Michael Jackson - Germaine Jackson - Smokey Robinson - Dionne Warwick - Cheryl Lynn - The Originals -

📞 **1-818-514-0038**
(Ext. 1)
Monday - Friday / 9am to 6pm

FIND US :

www.YourMusicConsultant.com
30721 Russell Ranch Road Suite 140 Westlake Village, USA
Email : info@yourmusicconsultant.com

New single available
17TH January

ANGIE WHITNEY
Can't We Get Along?

A TRIBUTE TO MARTIN LUTHER KING JR.
WRITTEN BY PAT BOONE, PRODUCED BY MICHAEL B. SUTTON

WW.ANGIEWHITNEY.COM

HOW CAN FASHION EMPOWER WOMEN?

You can practically visualize tToo often, we write fashion off as a frivolous idea.
After all, what need do we really have for nice shirts or our favorite pair of jeans in the long run?
There is also the idea that fashion can be detrimental to women.
This argument says that it pressures women to look a certain way and make those who don't feel worse about themselves.
These, at times, can be true but they overlook a key factor. Fashion can be used to empower women and make them feel fantastic. How can clothing and accessories do so much to empower women? That's what we are going to look at today.

IT CAN MAKE YOU FEEL CONFIDENT -
Whatever outfit works for you, feeling confident is key.

The most obvious way that fashion can empower women – or anyone, really – is how the right outfit can make you feel.

You can put on an outfit and it can make you feel a certain way.

For instance, a blazer and slacks or well-tailored suit can make you feel very powerful or a sleek cocktail dress can make you feel sexy and confident.

You should feel confident as you move through life and presenting yourself the way that feels best to you can go a long way towards achieving that.

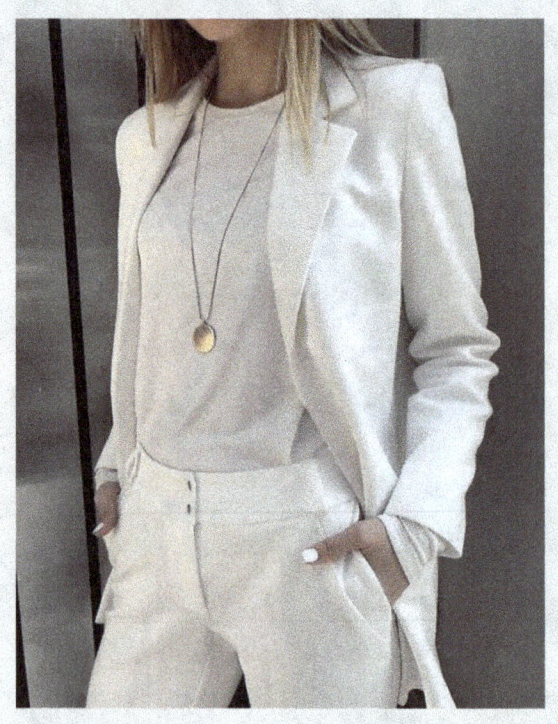

IT CAN HELP YOU SHOW YOUR PERSONALITY
We've all heard about the importance of first impressions.

That means that the clothing you wear can help you to show off your personal aesthetic.
For instance, if you are into the punk scene, a leather jacket and a good pair of black boots can go a long way in helping you feel like you are showing yourself in your style.

This, again, comes back to confidence.

If you feel like you are comfortable in what you are wearing and that it reflects your personality, you're going to be more confident in yourself.

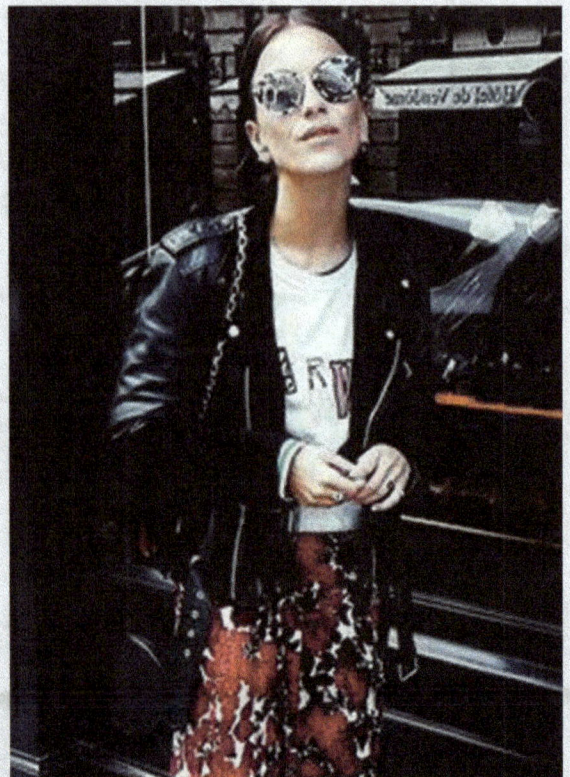

HOW CAN FASHION EMPOWER WOMEN?

EXPRESS YOUR CREATIVITY

Too often, we write fashion off as a frivolous idea.

After all, what need do we really have for nice shirts or our favorite pair of jeans in the long run?

There is also the idea that fashion can be detrimental to women.

This argument says that it pressures women to look a certain way and make those who don't feel worse about themselves.

These, at times, can be true but they overlook a key factor. Fashion can be used to empower women and make them feel fantastic. How can clothing and accessories do so much to empower women? That's what we are going to look at today.

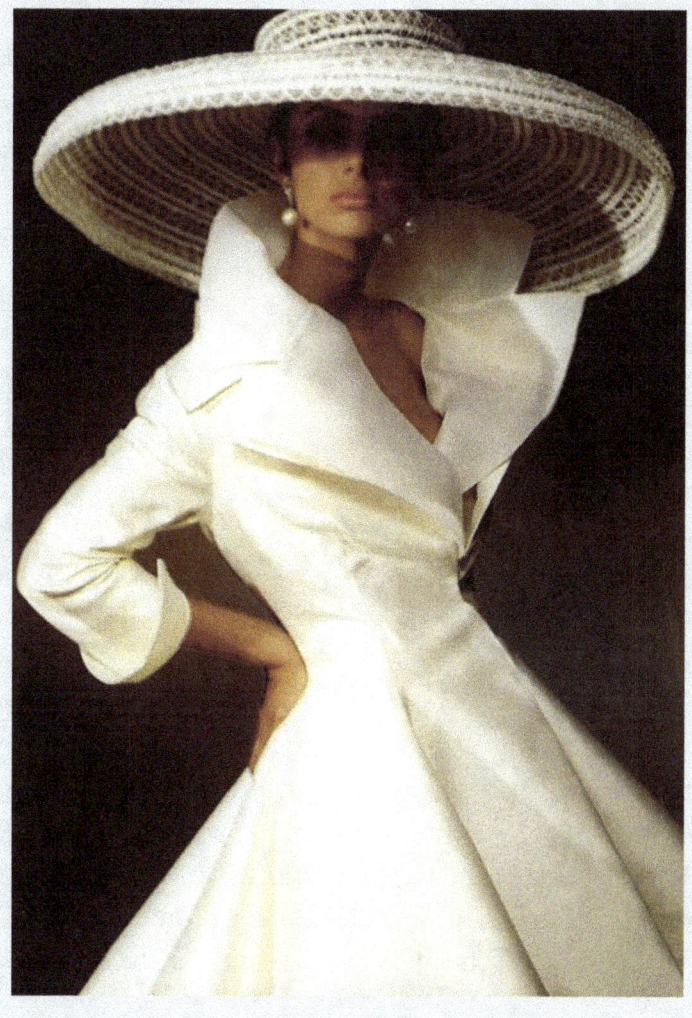

YOU CAN EXPRESS YOUR VIEWS AND OFFER SUPPORT

In the past few years, we've seen people wearing t-shirts that have slogans such as "The Future Is Female".

It is here, especially that we must remember that fashion is, in fact, an art form. The creation of designers, both professional and amateur, can carry heavy messages believed both by designers and those who wear their clothes.

This might not seem like much but it can be a lot. These designs can show other people that you support them or their cause and they can be the signal of a movement.

Fashion can be a point of solidarity and it can be a point of protest against what the designer and wearer thinks needs to be changed.

by ANNABELLE SHORT

HOW TO PROMOTE ON TiK ToK

1. Put your music on TikTok
CD Baby can deliver your music to TikTok for usage in short-form videos on the platform. Your songs will be available in TikTok's music library, where any user can pull it into one of their own videos. When one of your tracks gets used, you earn money.

Getting your music on TikTok is included with all CD Baby distribution.

2. Follow other musicians on TikTok
The best way to learn about TikTok is to get on there and start using it. Be sure to follow at least a few active musicians on the platform, too. Even if you don't love their music or genre, you'll learn what works for musicians who are willing to be creative on TikTok.

To get you started, check out the Jonas BrotherS, and Lizzo…

3. Keep it light
TikTok is a fun platform. If you're an artist who takes yourself super seriously, you might have a hard time creating content that connects with TikTok users.
There's a video of megastar Camila Cabello in the studio. Her mom stops by to say hi. Camila is psyched… to see that her mom has brought pizza. She runs right past her mom and starts eating a slice right up close to the camera.

If giant popstars can be silly and endearing, so can you. Lighten up!

4. Don't stress about being perfect
TikTok isn't about polish.
Flaws, quirkiness, awkwardness, sometimes even things that are offensive get the most traction on the platform. So don't be afraid to be you, and don't feel the pressure to look 100% before you hit record. Get silly. Be weird. Stay true.

5. TikTok skews young… but not forever
Almost half of TikTok's active users are between 16-24, so it's become the go-to app for younger audiences who are breaking ground and shaping new trends in music, comedy, and culture. If you're in that age range, you're probably not wondering if you need to be there. You already are. If you're older, you probably ARE asking if you need to be on TikTok. The answer (for any social media platform) is NO. You need to be wherever you can communicate with your fans most effectively.

But if you're in that "older" demographic, don't discount the platform outright; just as the 35+ crowd has widely embraced Instagram, the same could be true of TikTok in a few years. By getting in there now, you can shape how your generation's interests and music are featured on TikTok.

6. It's not about your song; it's about a musical moment
Familiarity. It's what makes a radio hit, a playlist hit, and a TikTok hit.
TikTok gives you a chance to share a HOOK, over and over again.

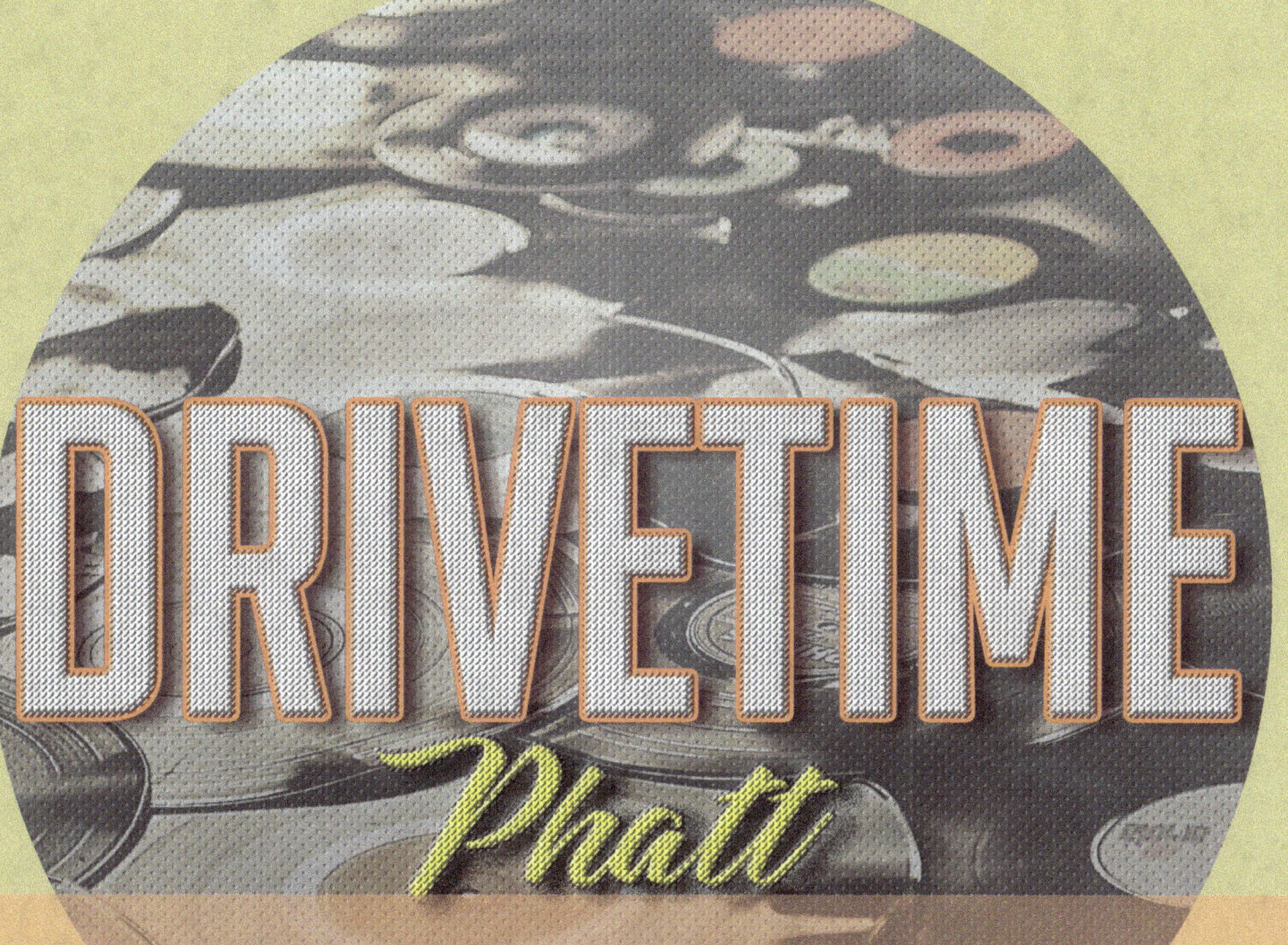

TEENS USING GIRL POWER TO CHANGE THE WORLD

There are 1.1 billion girls in the world today (!); each full of power, strength, creativity and potential. While we celebrate every one of those girls, lets take a look at hese awesome teenagers who are harnessing their inner girl power to make this world a better place!

AMANDLA STENBERG, 18, UNITED STATES

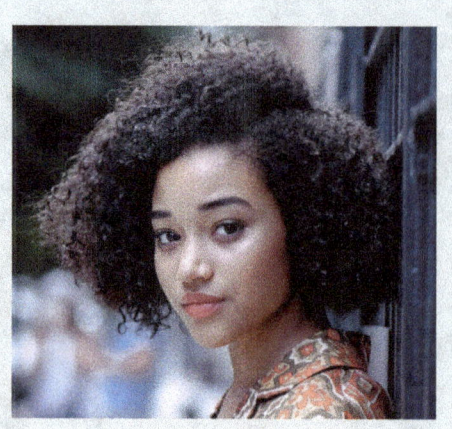

Amandla Stenberg is an actress, musician, director, author and activist. To be honest there's not much she can't do! Stenberg has spoken out about topics such as cultural appropriation, gender binaries, sexuality and intersectional feminism. She is quickly becoming the voice of her generation as she uses her fame and popularity for nothing but good.

KIARA NIRGHIN, 16, SOUTH AFRICA

Kiara Nirghin is an aspiring scientist from South Africa, which is experiencing the worst drought since 1982. Nirghin set out to create a superabsorbant polymer (SAP) that could be sprinkled over dirt to make it retain massive quantities of water, much like diapers do. She wanted it to be cheaper and more eco-friendly than more traditional options, which contain chemicals like acrylic acid. So she used natural products like avocados and oranges, the peels of which, Nirghin discovered, can be turned into an SAP by applying a certain amount of UV light and heat.
Her experiment won the grand prize at this year's Google Science Fair. Nirghin hopes to develop it for commercial use, so that any country can use it during a drought.

JOSIE POHLA, 16, AUSTRALIA

After her mother's suicide, Josie started an online petition and wrote to the New South Wales government, which led to the inclusion of material on domestic violence in the high school syllabus. She received over 100,000 signatures and had messages of support from people who shared their personal experiences of domestic violence. The Prevention of Domestic Violence Program is now in run for years 7 to 10 in NSW schools.